THE UNOFFICIAL
Horror Movie
COLORING BOOK

From **The Exorcist** and
Halloween to **Get Out** and **Child's Play**,
30 Screams and Scenes to *Slay* with Color

Vernieda Vergara

Illustrated by Andy Price

Adams Media
New York London Toronto Sydney New Delhi

Adams Media
An Imprint of Simon & Schuster, Inc.
100 Technology Center Drive
Stoughton, Massachusetts 02072

First Adams Media trade paperback edition July 2023

ADAMS MEDIA and colophon are registered trademarks of Simon & Schuster, Inc.

For information about special discounts for bulk purchases, please contact Simon & Schuster Special Sales at 1-866-506-1949 or business@simonandschuster.com.

The Simon & Schuster Speakers Bureau can bring authors to your live event. For more information or to book an event, contact the Simon & Schuster Speakers Bureau at 1-866-248-3049 or visit our website at www.simonspeakers.com.

Illustrations by Andy Price
Images © Simon & Schuster, Inc.

Manufactured in the United States of America

10 9 8 7 6 5 4 3 2 1

ISBN 978-1-5072-2136-5

Author's Note: All of the illustrations in this book are original creations and do not depict actual scenes from the movies upon which they are based.

INTRODUCTION

Creepy dolls possessed by evil demons…
The undead poised to attack…
Homicidal maniacs on the loose…

Gather 'round, lovers of the jump scare and eerie abandoned house. It's time to revisit your favorite horror stories of hauntings from beyond the grave, psychotic killers hell-bent on revenge, and generational curses no one can outrun. Petrifying, creepy, and fright-packed scenes paying tribute to your favorite horror movies are brought to life in *The Unofficial Horror Movie Coloring Book*!

Within the pages of this book, you can relive that unforgettable twist, that shocking death, and that moment of dreadful realization from horror's most iconic films. Whether you're a longtime aficionado who can't get enough thrills and chills or a newer fan who still peeks through your fingers, this coloring book offers thirty images to bring to terrifying life, including ones inspired by:

- That infamous shower scene in *Psycho*
- Michael Myers stalking Laurie in *Halloween*
- *Get Out*'s the Sunken Place
- Samara emerging from the well in *The Ring*
- *Midsommar*'s May Queen
- And more!

Do you have what it takes to survive? Then pick up your colored pencils and markers and enter a world of colorful nightmares with *The Unofficial Horror Movie Coloring Book*!

More about the Movies

Horror films run the gamut in terms of plot twists, maniacal villains, and thought- and fright-provoking scenes. This movie genre also impressively spans many storytelling styles, directorial approaches, and subgenres. But even with that diversity, some films stand out for their legacies and influence upon the genre. Here are some of the films that inspired the images you'll find in this coloring book.

• *Halloween.* Released in 1978 as an independent film, *Halloween* introduced the world to the serial killer Michael Myers. While it wasn't the first slasher horror film, it's widely considered to be the movie that served as the blueprint for the subgenre as it is today. Inspiring a new wave of horror movies during the 1980s, *Halloween* cemented many now-popular tropes, including the Final Girl—as portrayed by Jamie Lee Curtis (in her first feature role) as the film's heroine, Laurie.

• *A Nightmare on Elm Street.* Wes Craven's *A Nightmare on Elm Street* launched one of horror's most iconic villains in Freddy Krueger with his trademark fedora, striped sweater, and bladed glove. While the franchise continued the 1980s horror movie trend of cautioning against teenage promiscuity, the series shines in its exploration of adolescent anxiety.

• *House on Haunted Hill.* Inspired by Shirley Jackson's *The Haunting of Hill House, House on Haunted Hill* is a classic B-horror movie from the 1950s. Featuring a cast led by the unforgettable Vincent Price, it made effective use of low-budget props to deliver scares and chills—something that would inspire Alfred Hitchcock to make a little-known film called *Psycho.*

• *Night of the Living Dead.* George Romero made his directorial debut with *Night of the Living Dead*, a film that not only became known as the first modern zombie movie but also a major force in the development of cinematic horror. It would go on to kick-start a franchise famous for its commentary on contemporary culture and current events. As for this first film, it's also famous for casting Duane Jones, a Black actor, in the lead role—something that was rare in 1968.

• *Annabelle.* The real-life exploits of paranormal investigators Ed and Lorraine Warren inspired a cinematic universe of supernatural horror films known as The Conjuring. Featured in a cameo in the first Conjuring film, the haunted doll known as Annabelle would capture the imagination of countless fans. Based on a real doll housed in the Warrens' occult museum, Annabelle would serve as the focus of three feature films.

• *Child's Play. Child's Play* injected new life into 1980s horror, which by the end of the decade had become stale. While creepy doll movies were nothing new, *Child's Play* introduced Chucky, who wasn't the more genre-familiar antique porcelain doll. Instead, Chucky was a popular toy that every kid wanted and that no one would ever associate with gruesome murder.

• *Saw.* The Saw films won over horror fans with their sadistic yet imaginative games designed to test victims' wills to live. The first film was the feature directorial debut of James Wan, who would go on to direct other horror films such as *The Conjuring, Insidious,* and *Malignant.* At their height, Saw movies became an annual Halloween tradition, with a new installment dropping on every horror fan's favorite holiday.

• *Scream.* Twelve years after Wes Craven introduced Freddy Krueger, he gave the world *Scream. Scream* satirized the slasher tropes cemented in earlier films like *Halloween* and, yes, *A Nightmare on Elm Street.* With its genre subversions and horror-savvy characters, the film would revive the slasher genre in the late 1990s.

• *The Evil Dead.* Before Sam Raimi and Bruce Campbell became fan favorites of genre aficionados everywhere, they worked on a film together as director and lead actor, respectively. While that film, *The Evil Dead*, would eventually become a franchise, it would also serve as the foundation of the cabin horror film subgenre.

• *The Exorcist.* Even though *The Exorcist* is probably most famous for its head-spinning scenes featuring the possessed Regan, the film left behind an impressive legacy. It was the first horror film nominated for a Best Picture Oscar, which was only one of the ten Academy Award nominations it received. Beyond the accolades, the commercial success of *The Exorcist* elevated the genre and encouraged other film studios to invest in big-budget horror films.

• *Hellraiser. Hellraiser* shocked audiences with its pervasive body horror, gothic aesthetics, and eroticism, and left them enthralled with its memorable villain, Pinhead. As the leader of the Cenobites—interdimensional beings that are part angel and part demon—Pinhead's place in the horror pantheon endures, no matter what gender they may embody.

• *The Ring. The Ring* intrigued unsuspecting viewers with the phrase "seven days," and then proceeded to stun them when an unplacated malevolent ghost crawled out of a television. The film—an American remake of the Japanese movie *Ringu*—ushered in a wave of American remakes of Japanese horror titles, including *The Grudge* and *Dark Water.*

• *Suspiria.* Dario Argento's *Suspiria* (1977) remains one of the most influential horror films of all time due to its stunning visuals and exacting attention to color. By contrast, Luca Guadagnino removed that garish visual explosion in his 2018 remake of the film, choosing instead to focus on the body horror inherent to professional dance.

• *Midsommar.* Cults are nothing new to the horror genre, but *Midsommar* sparked a conversation about grief, toxic masculinity, and failing relationships. It also reignited an interest in the folk horror subgenre.

• *Get Out.* Jordan Peele emerged as a notable director of psychological horror with *Get Out*, which is about a Black man who visits his white girlfriend's family. Filled with social commentary, the film explores the racial dynamics woven throughout American society and how even the most liberal-seeming of people will uphold an unfair system that benefits them.

• *Dawn of the Dead. Dawn of the Dead* follows *Night of the Living Dead* as the second installment of George Romero's zombie film series. Unlike its predecessor, *Dawn of the Dead* portrays the zombie apocalypse from a wider societal standpoint. With its survivors barricading themselves in a mall and wallowing in a self-indulgent lifestyle while the world falls apart outside, the film offers sharp commentary on mindless consumerism.

• *The Texas Chain Saw Massacre. The Texas Chain Saw Massacre* is one of the most influential and controversial horror films in history. While its reputation as a blood-soaked gorefest eclipses the reality, especially by today's standards, the movie shocked audiences in 1974 with its brutal violence. A foundational film in the slasher subgenre, *The Texas Chain Saw Massacre* popularized many recognizable horror hallmarks, including the looming threat presented by its villain, Leatherface, and the types of weapons he uses to kill his victims.

• *Candyman.* Despite being a supernatural horror film, gothic romance serves as the driving force behind *Candyman*'s titular villain and the fascination the heroine holds for him. Set in the Cabrini-Green projects of Chicago, the movie explored race and class against a backdrop of urban legend and contemporary folklore.

• *The Amityville Horror. The Amityville Horror* chronicled the experiences of a young couple who moves into a haunted house. The film's notoriety, however, stems from the claims that it's based on true events, even though the veracity of these accounts remains highly in question.

• *Psycho.* Considered by many to be Alfred Hitchcock's most famous film, *Psycho* pushed the limits of on-screen violence in 1960. The shower scene in which Janet Leigh's character is murdered remains one of the most iconic scenes in all of cinema, not just the horror genre.

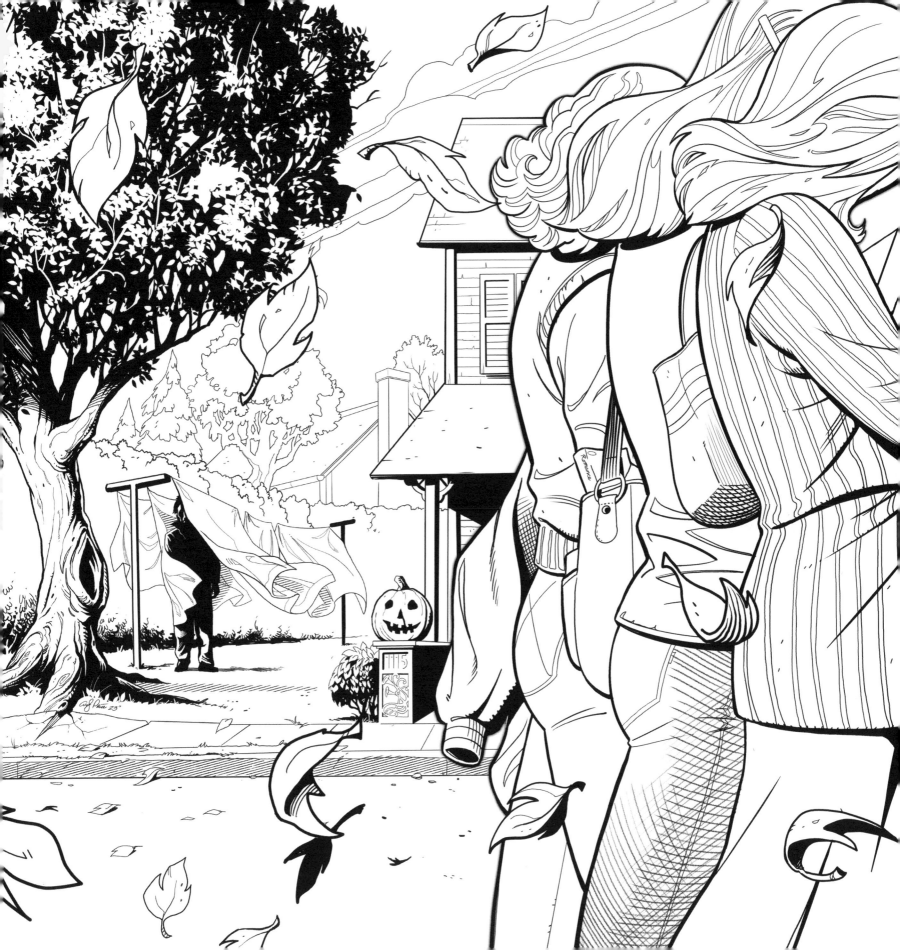

Halloween, 1978

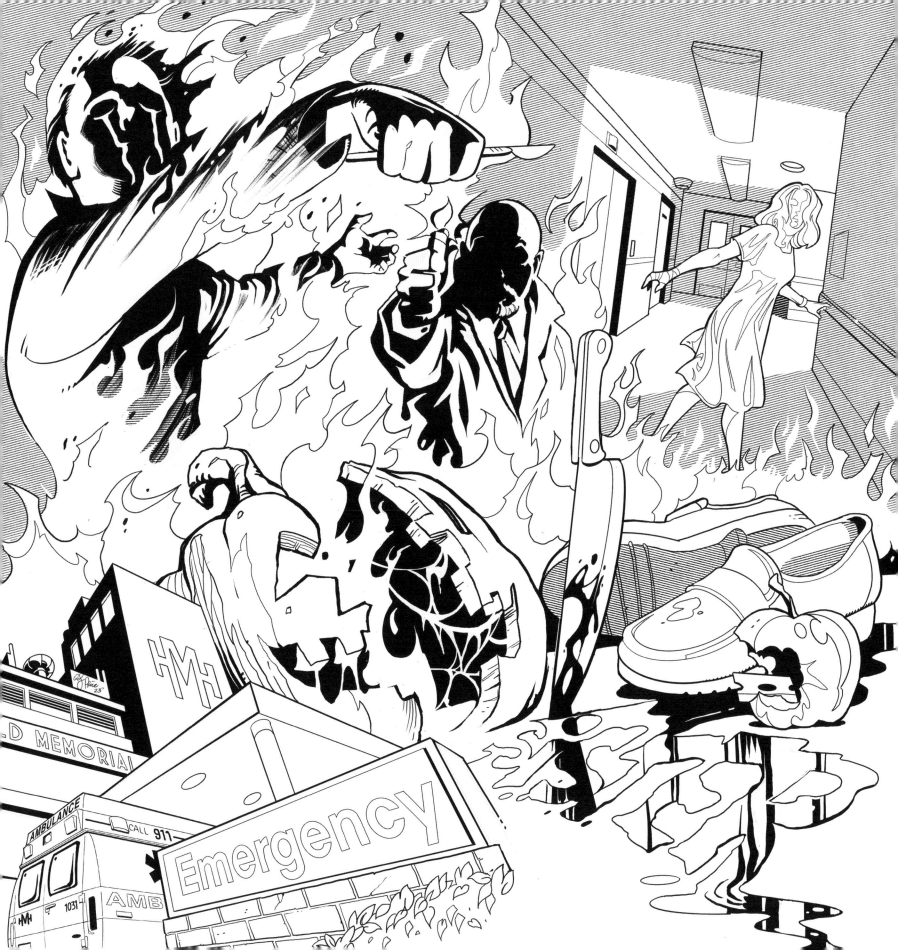

Halloween II, 1981

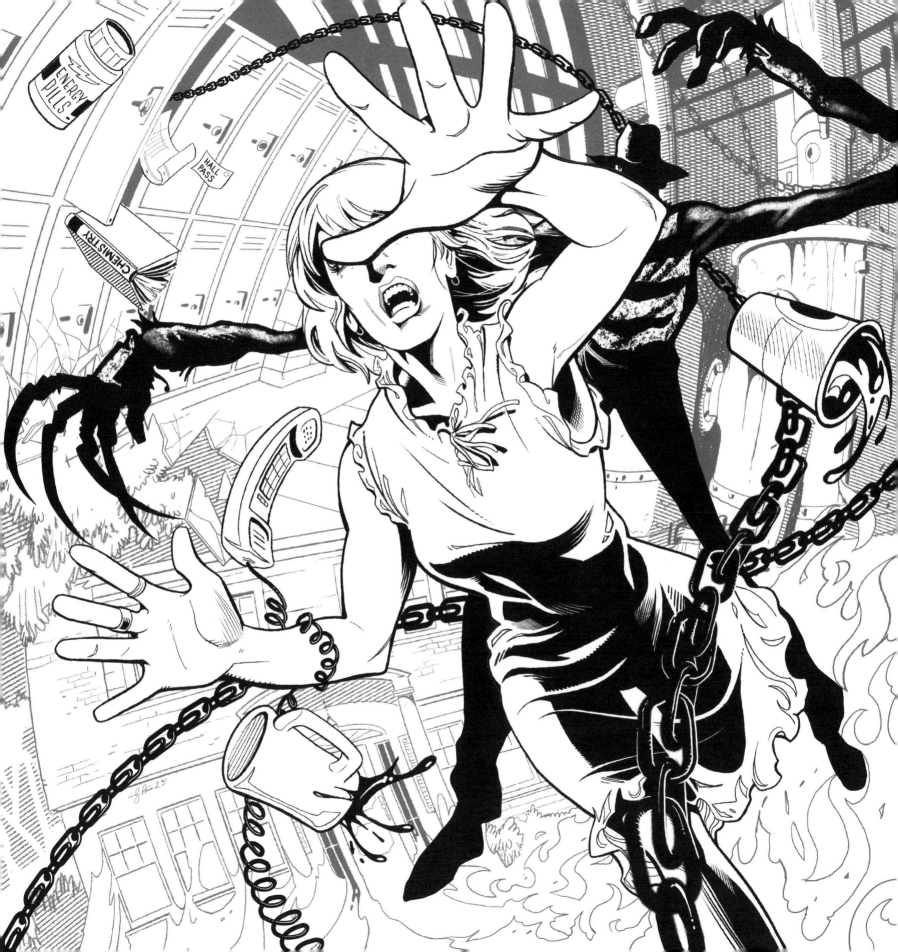

A Nightmare on Elm Street, 1984

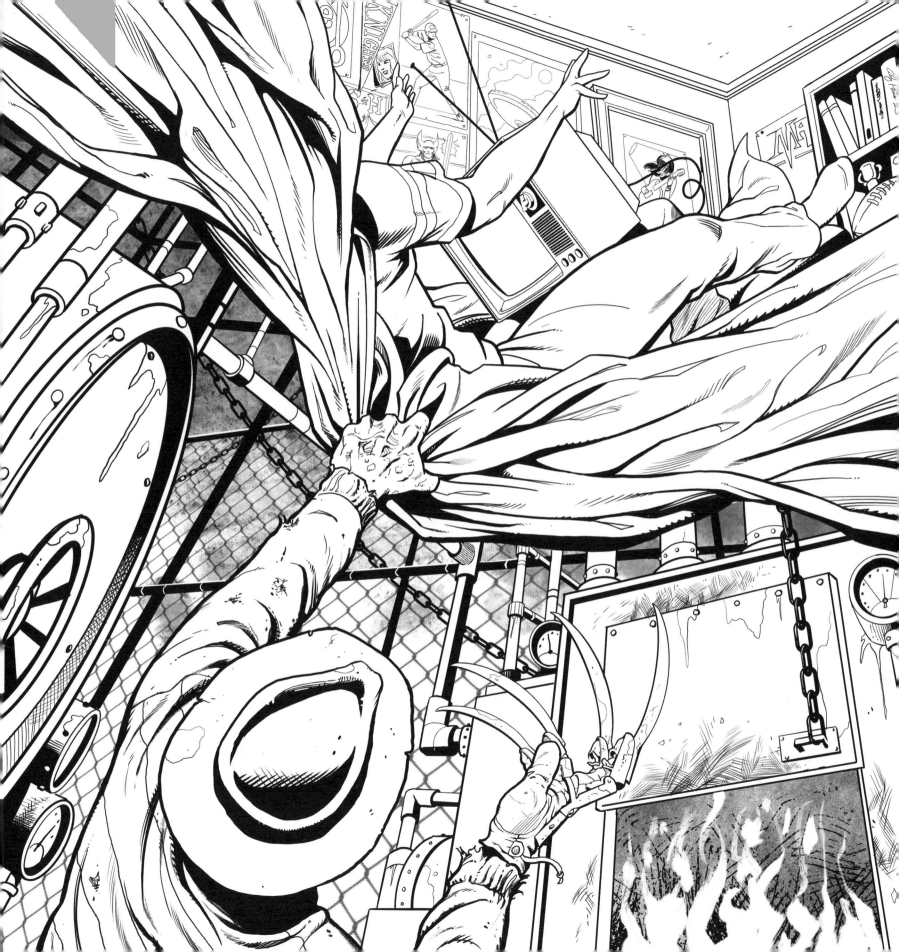

A Nightmare on Elm Street, 1984

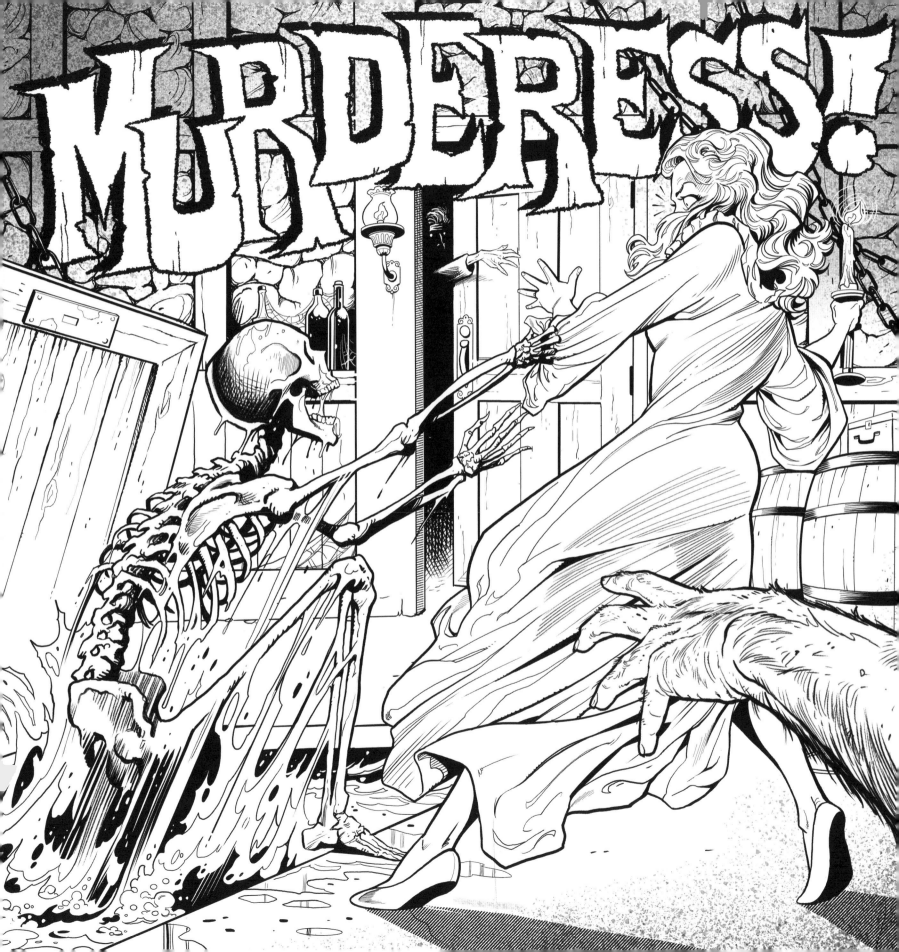

House on Haunted Hill, 1959

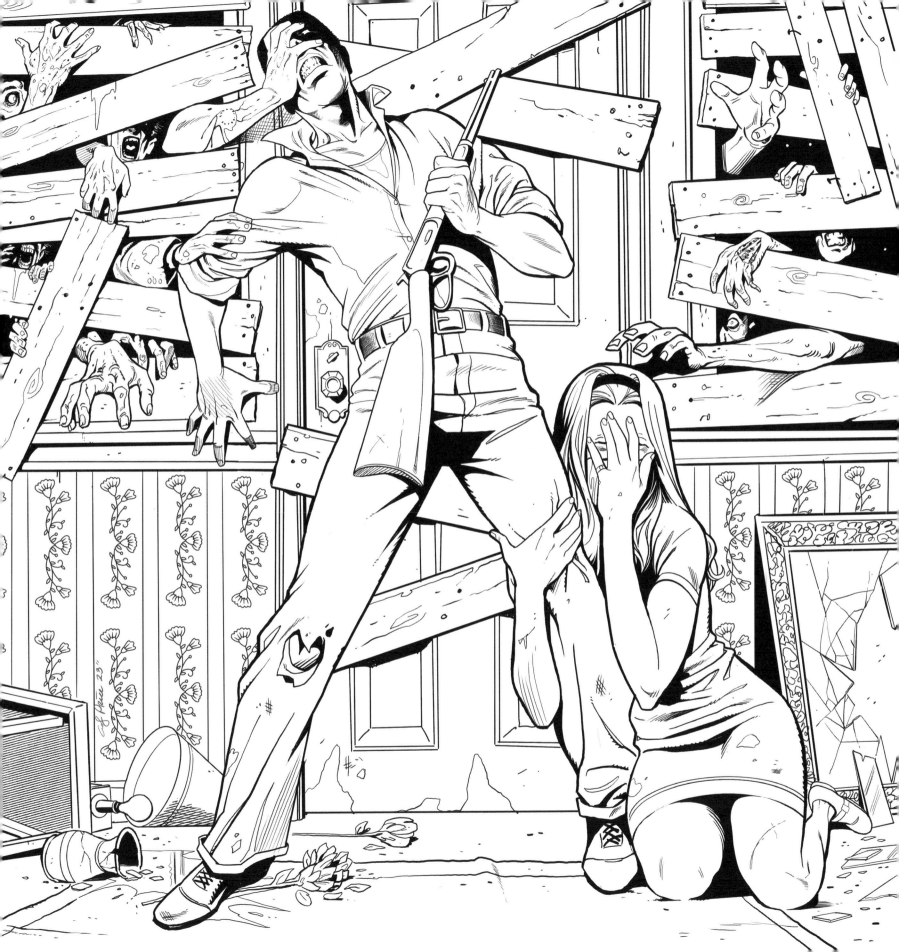

Night of the Living Dead, 1968

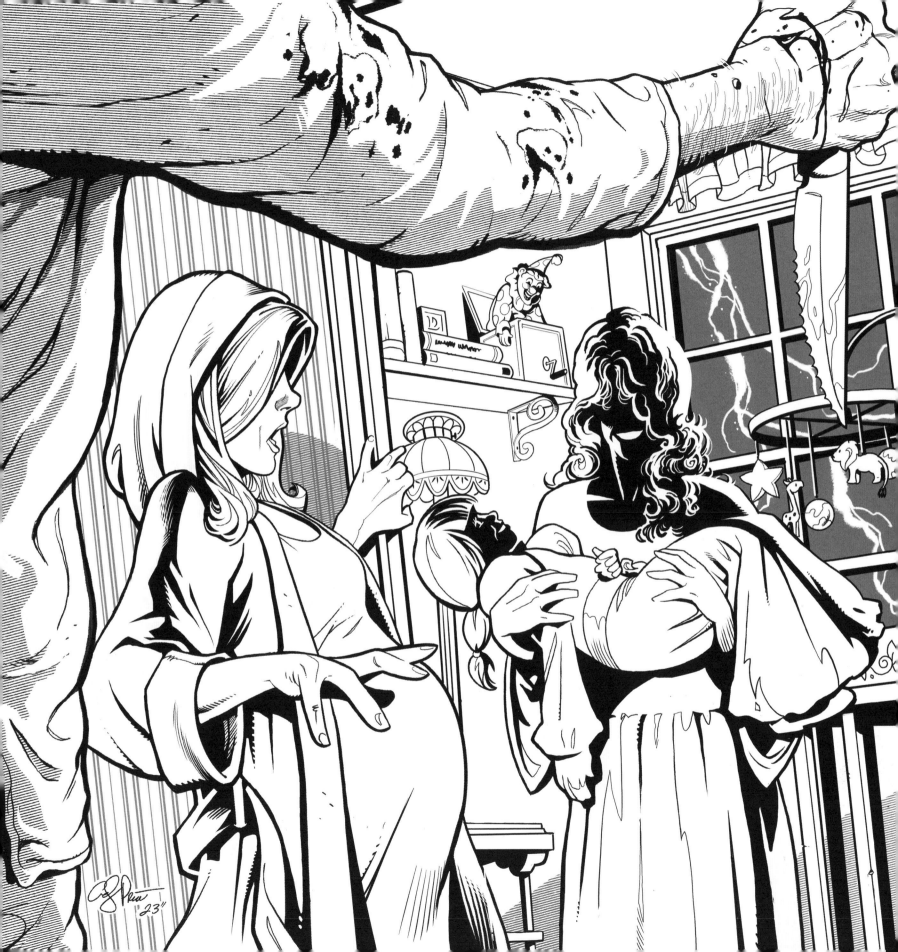

Annabelle, 2014

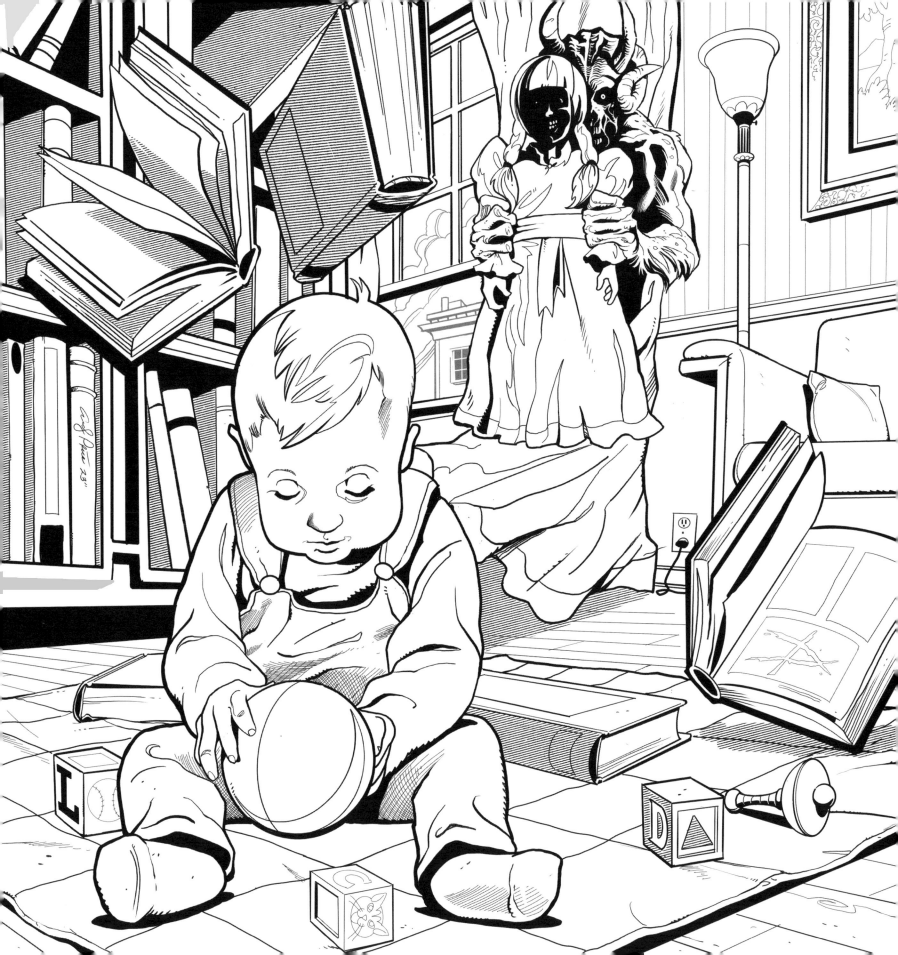

Annabelle, 2014

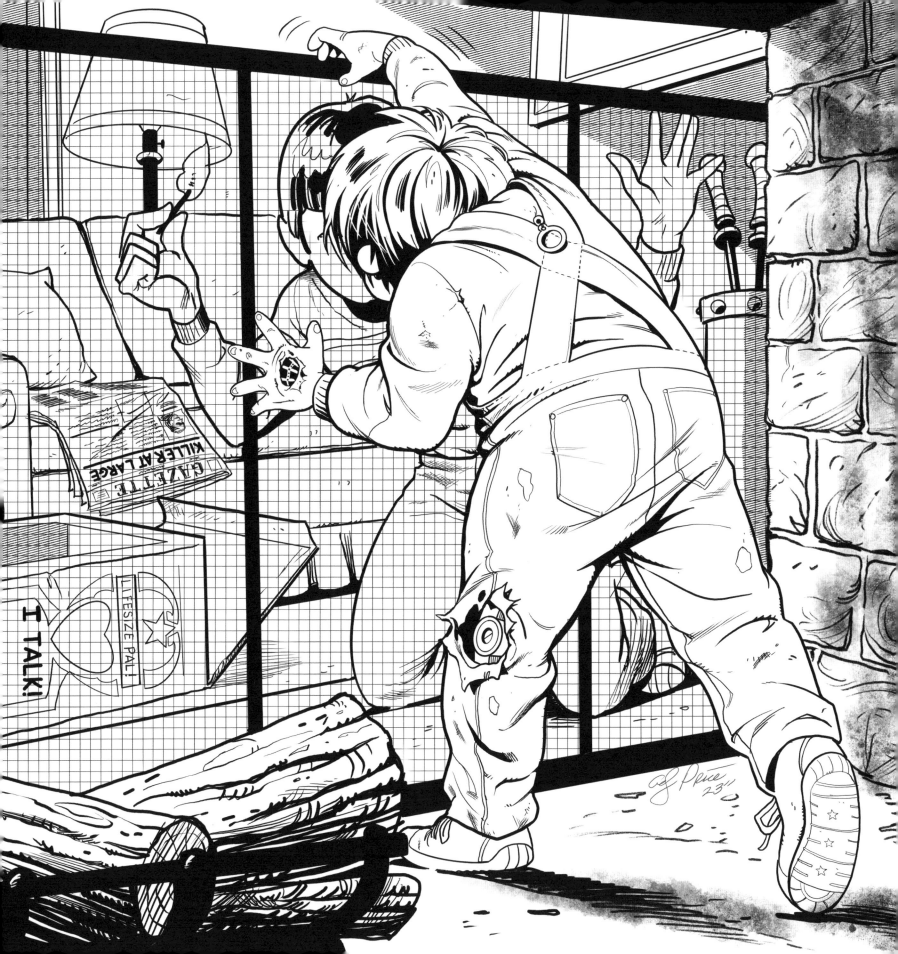

Child's Play, 1988

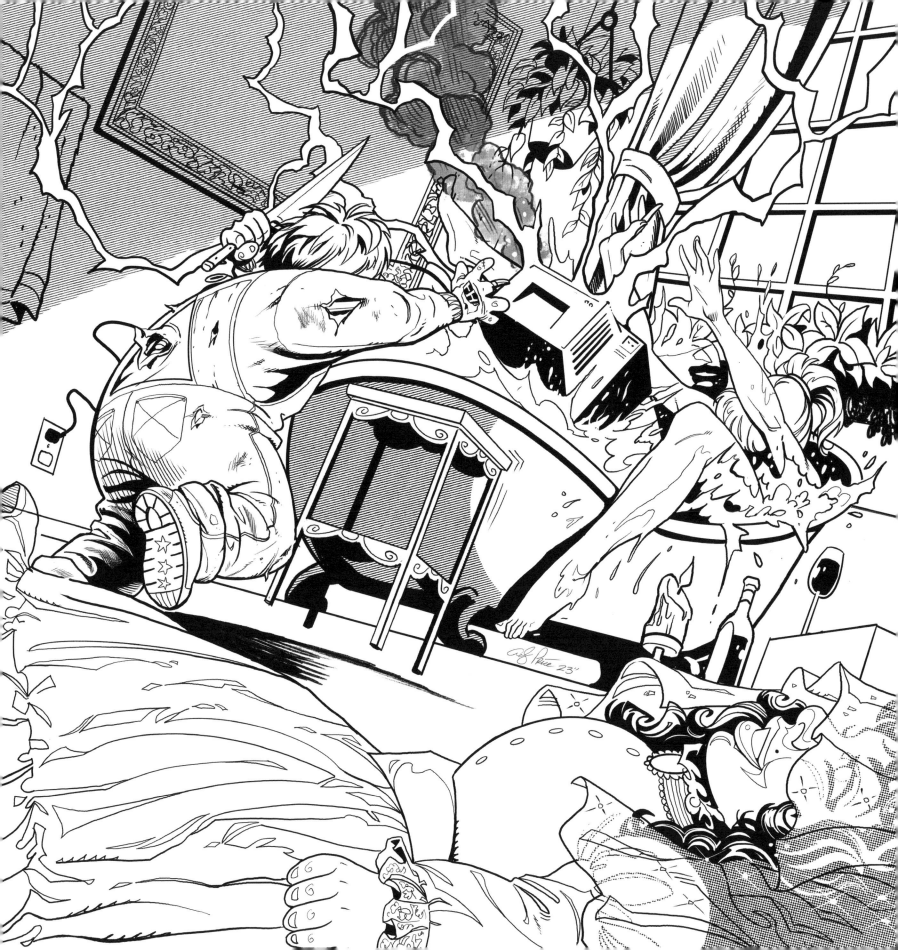

Bride of Chucky, 1998

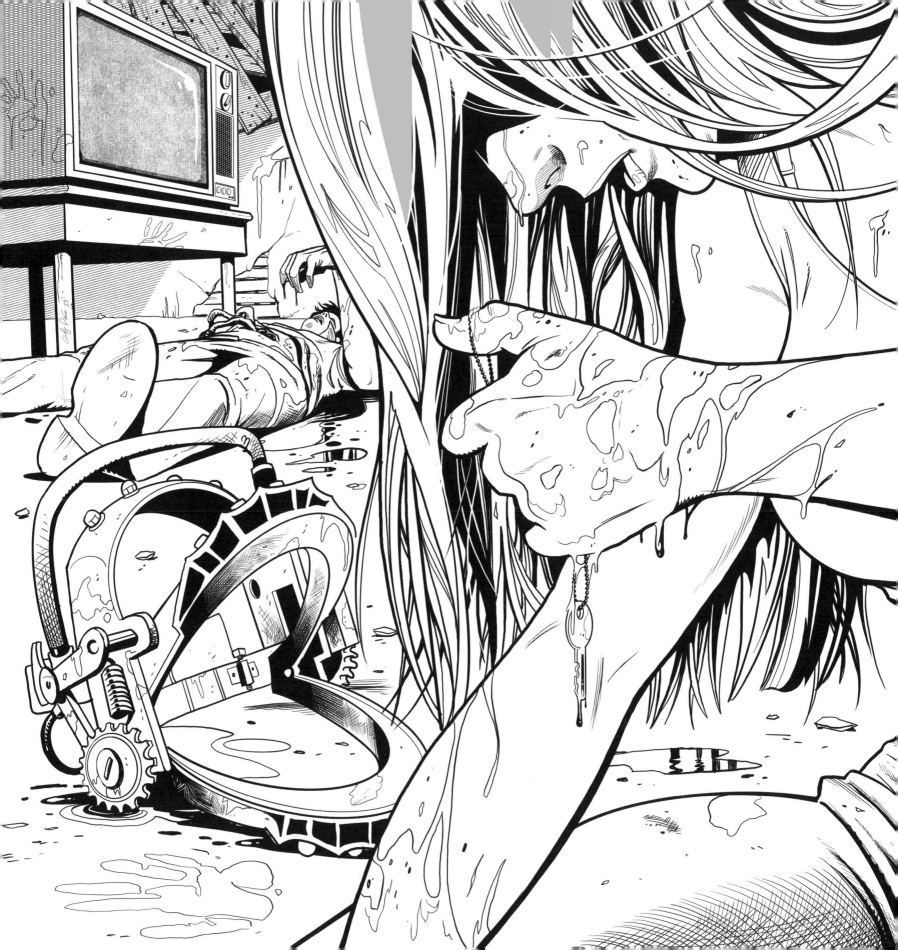

Saw, 2004

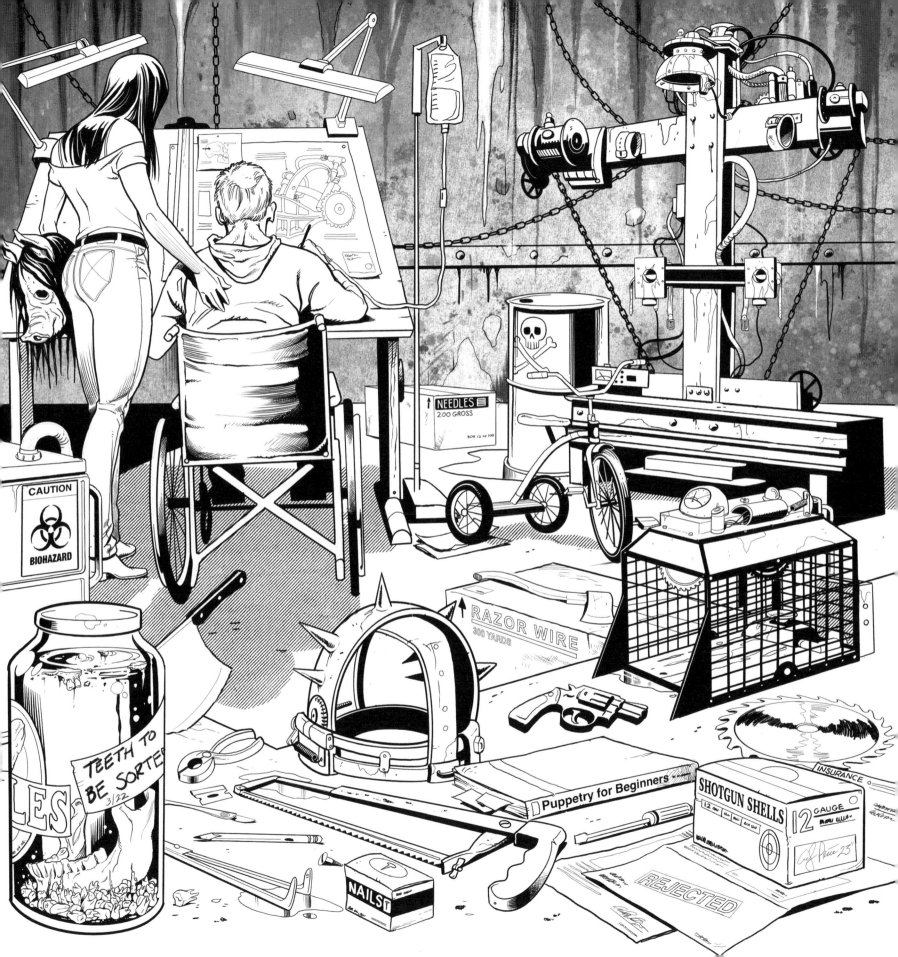

Saw VI, 2009

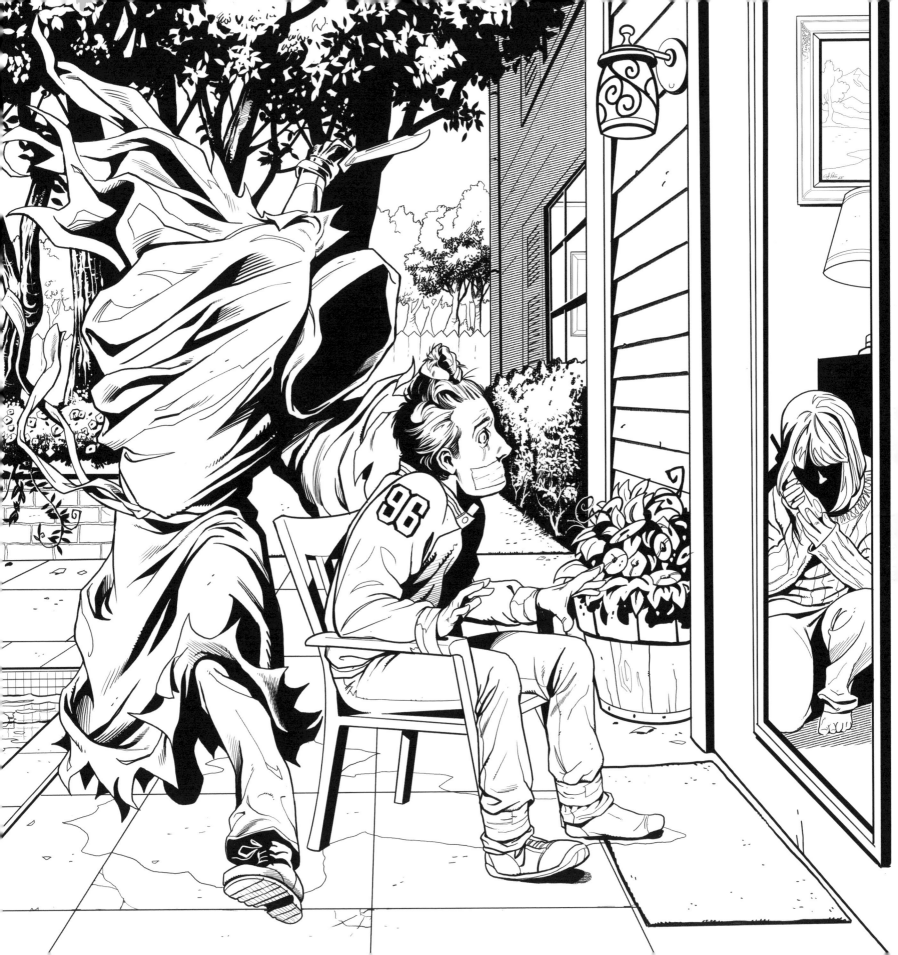

Scream, 1996

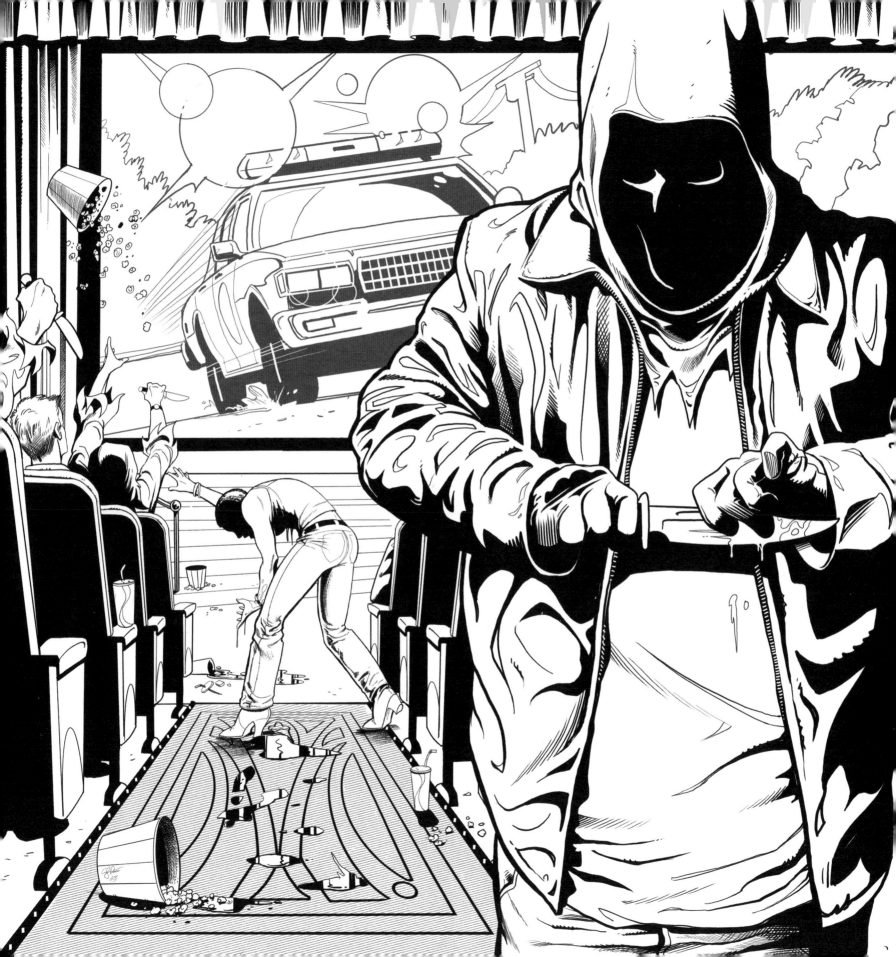

Scream 2, 1997

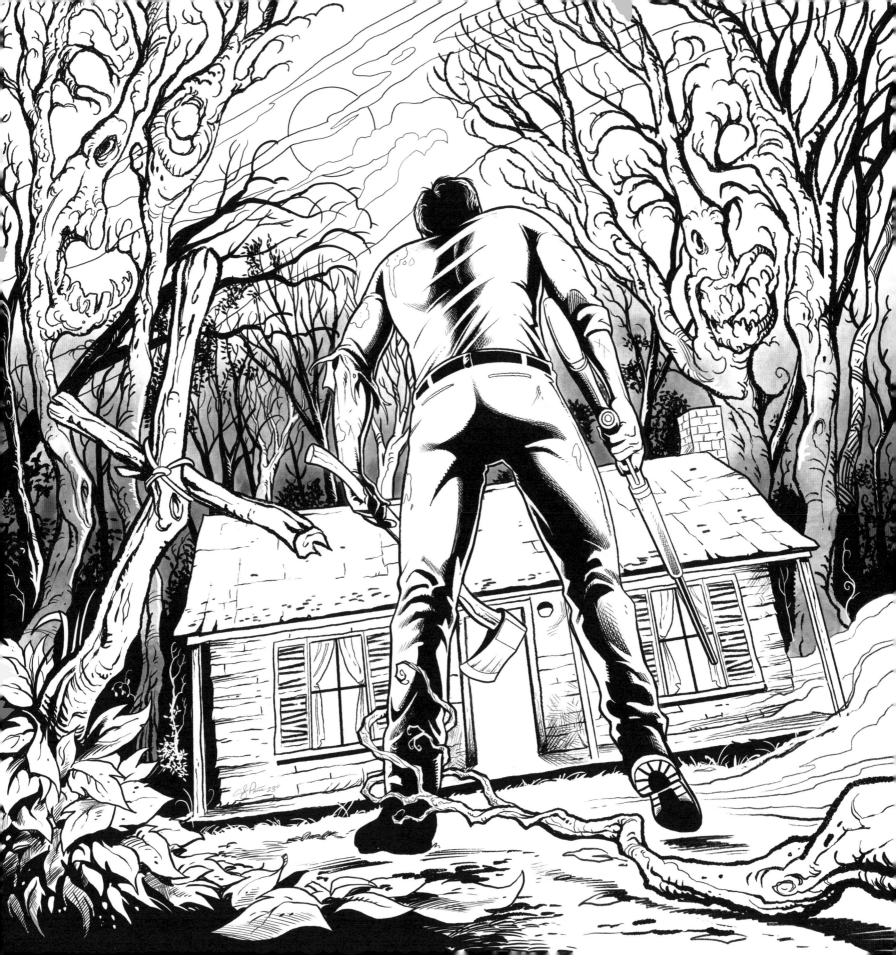

The Evil Dead, 1981

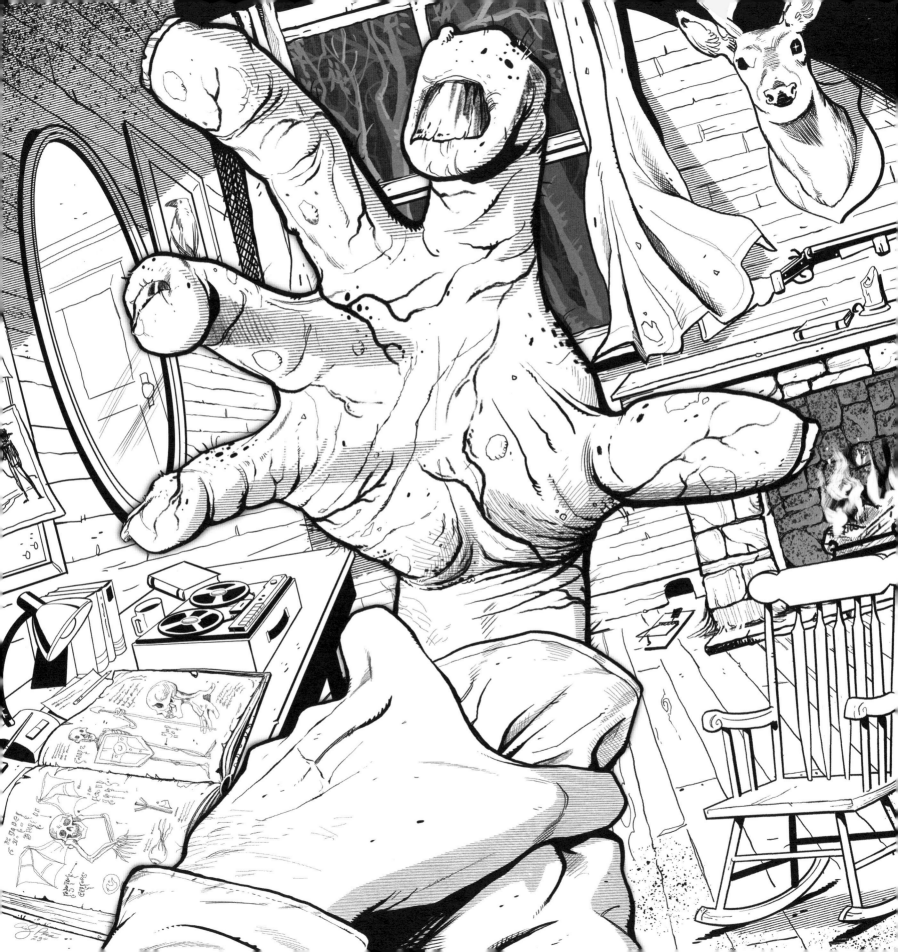

Evil Dead II, 1987

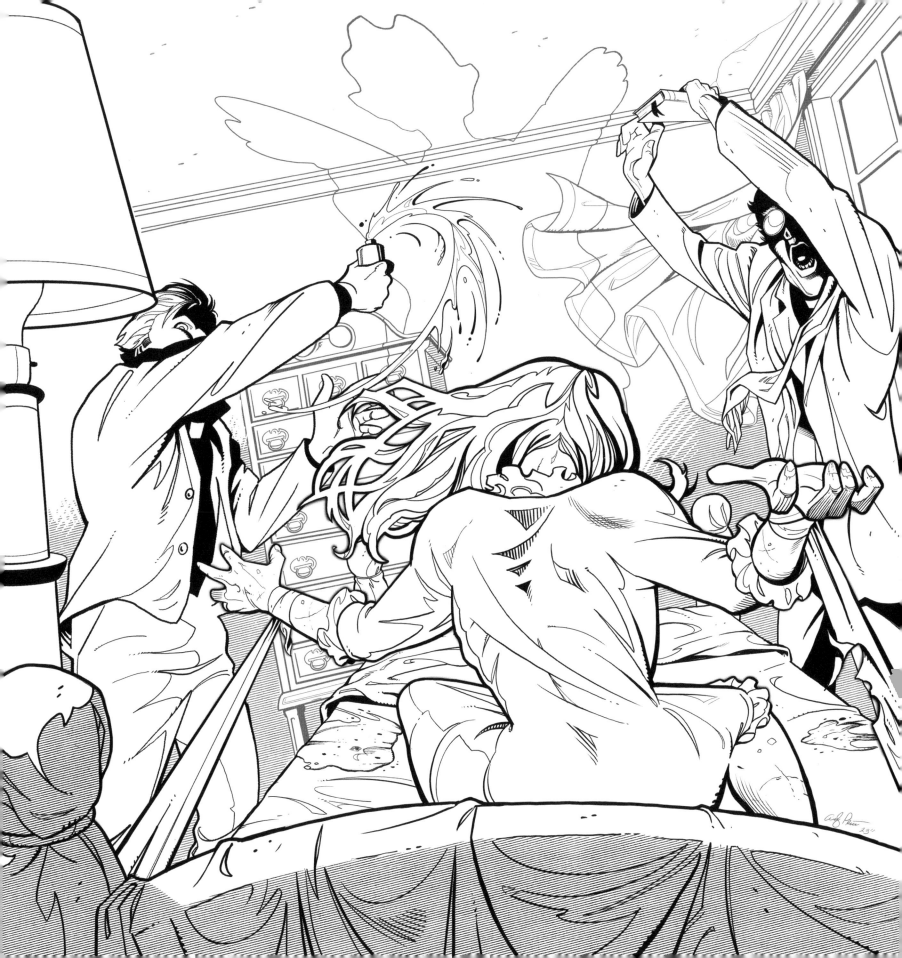

The Exorcist, 1973

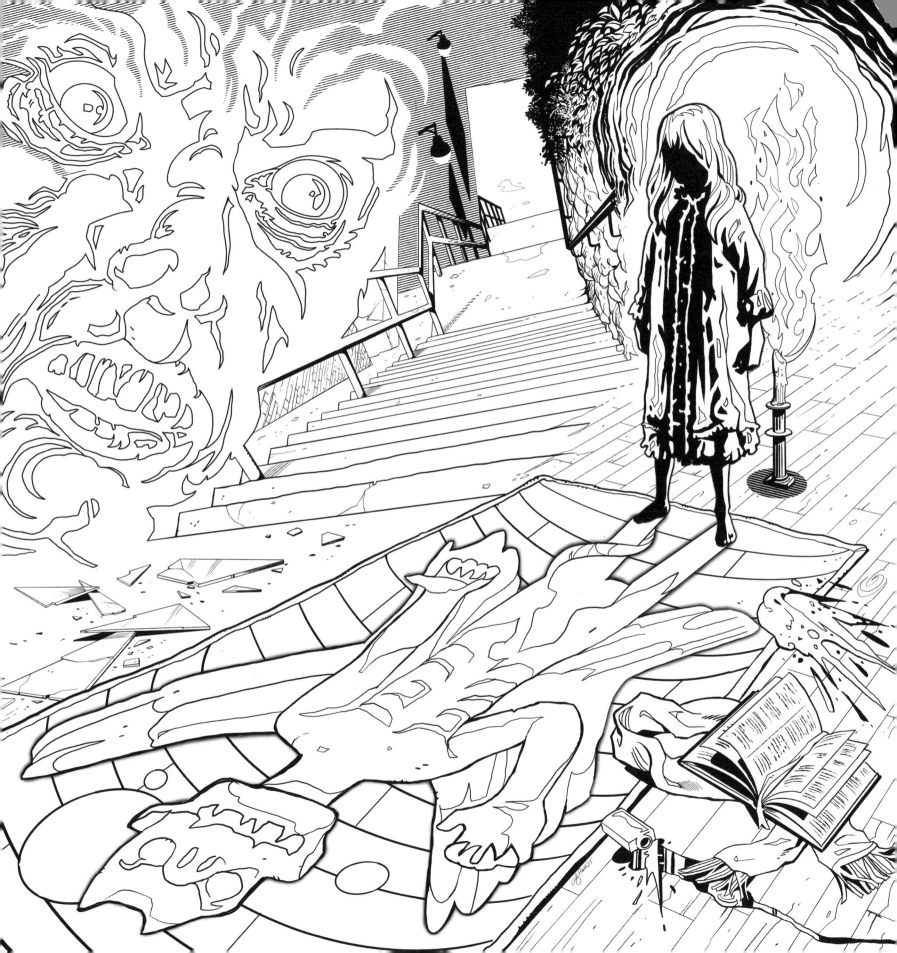

The Exorcist, 1973

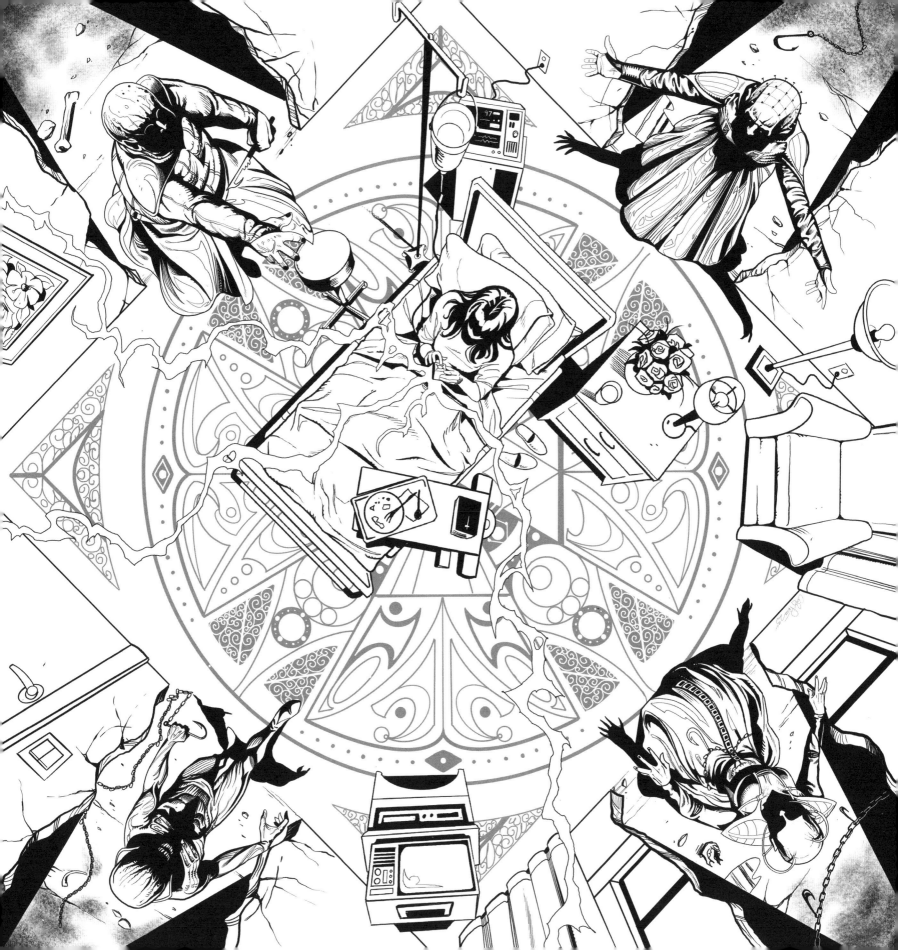

Hellraiser, 1987

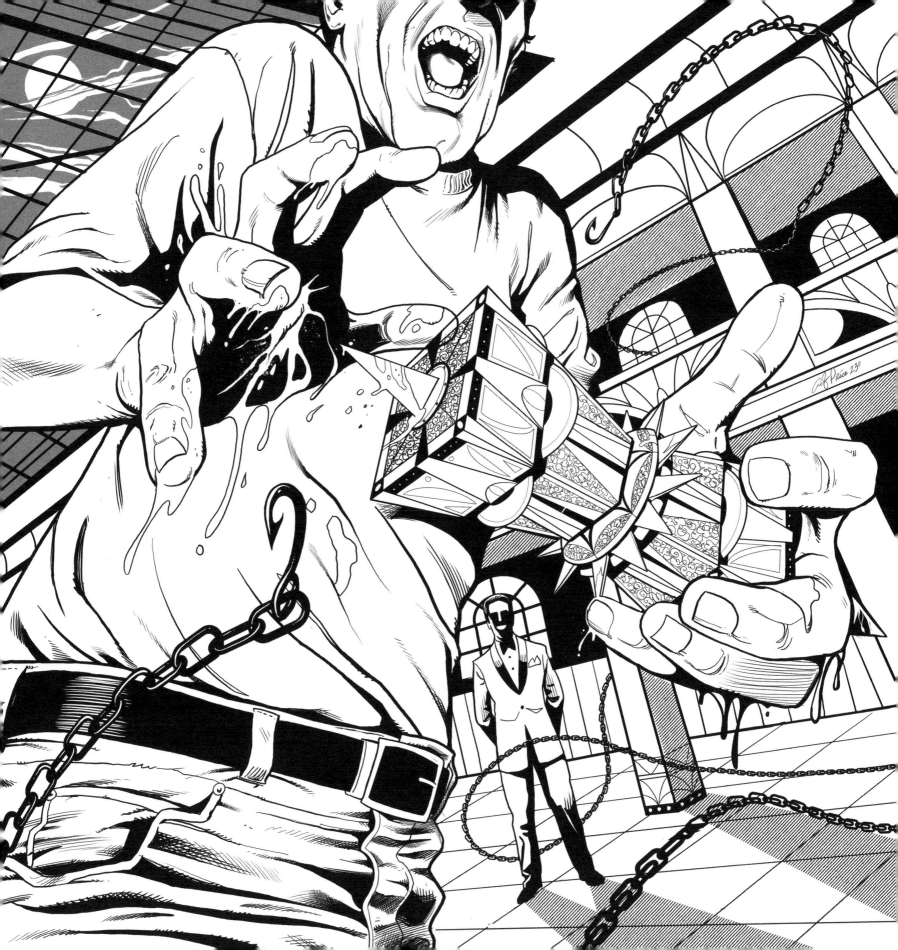

Hellraiser (Hulu release), 2022

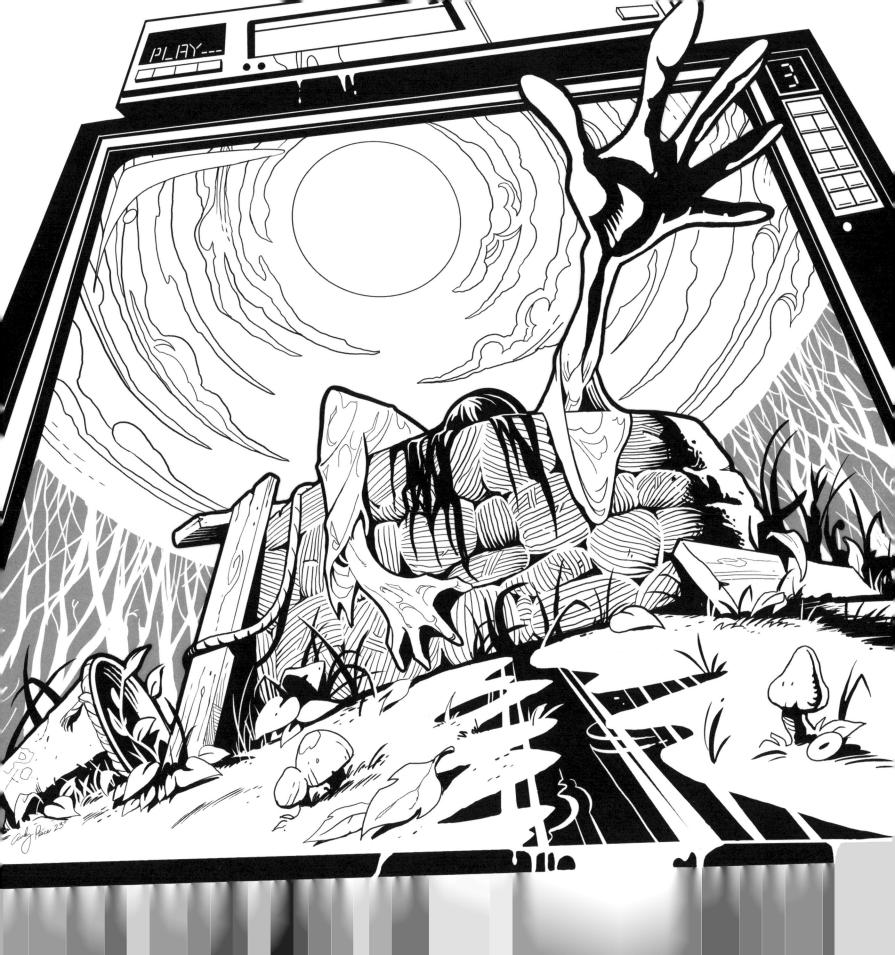

The Ring (US version), 2002

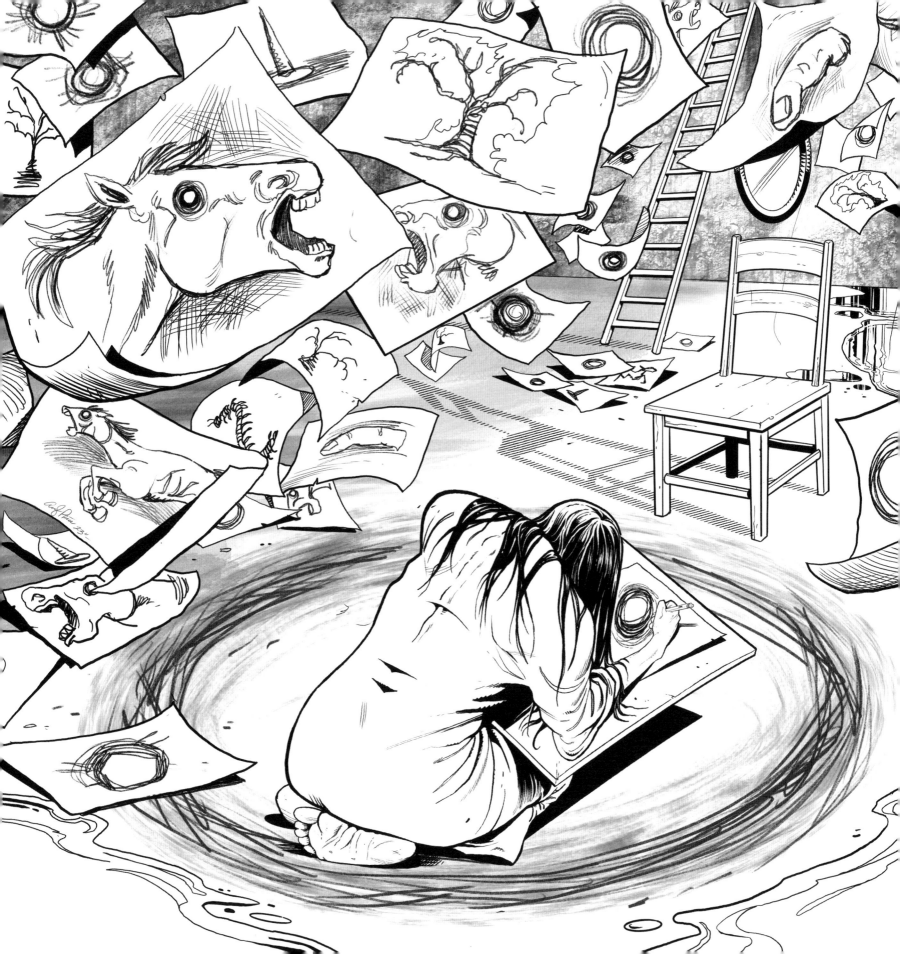

The Ring (US version), 2002

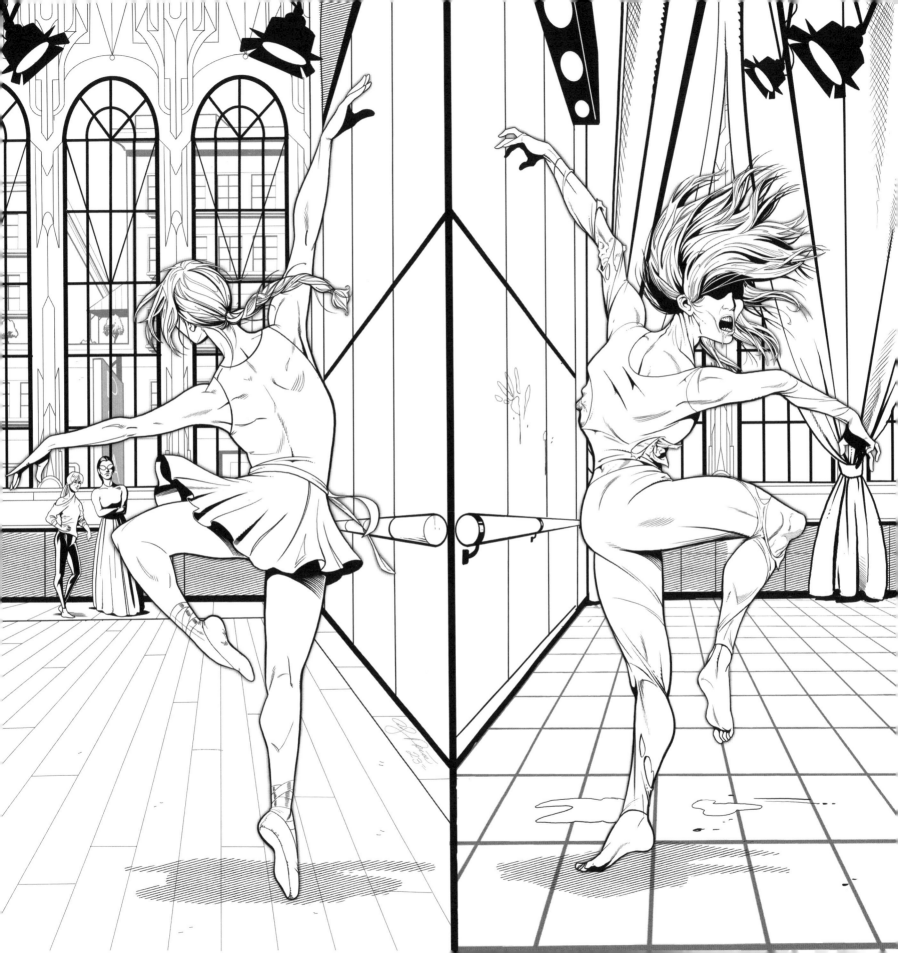

Suspiria, 2018

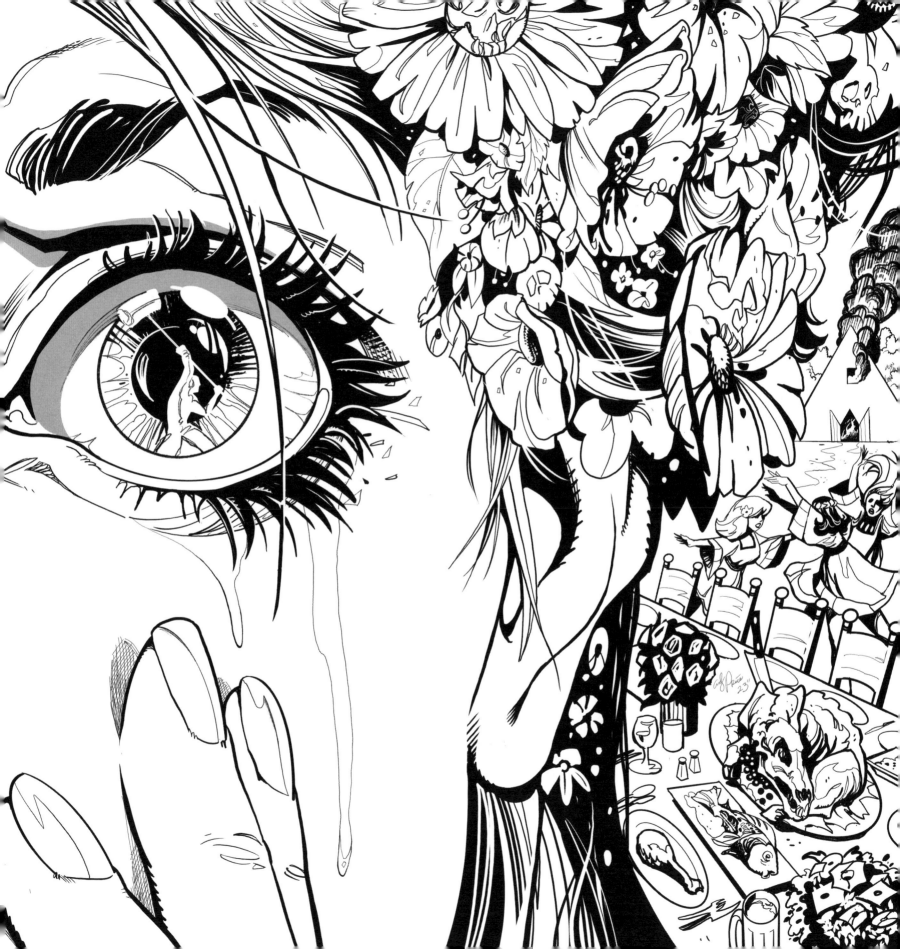

Midsommar, 2019

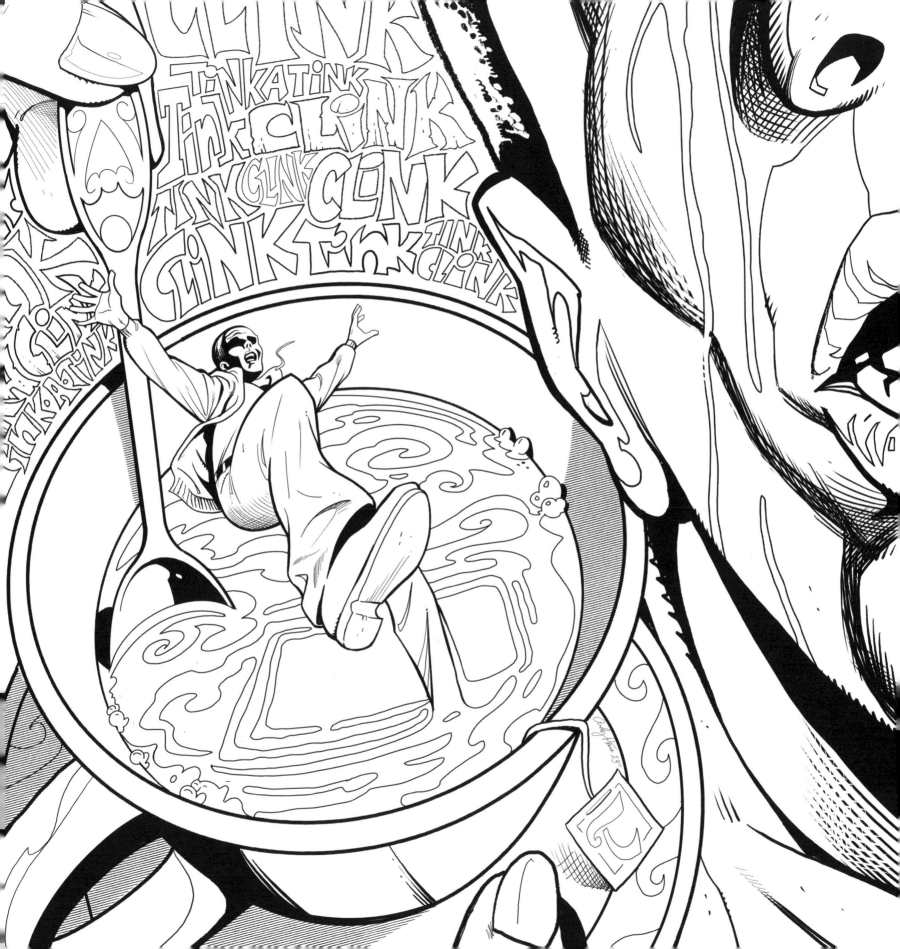

Get Out, 2017

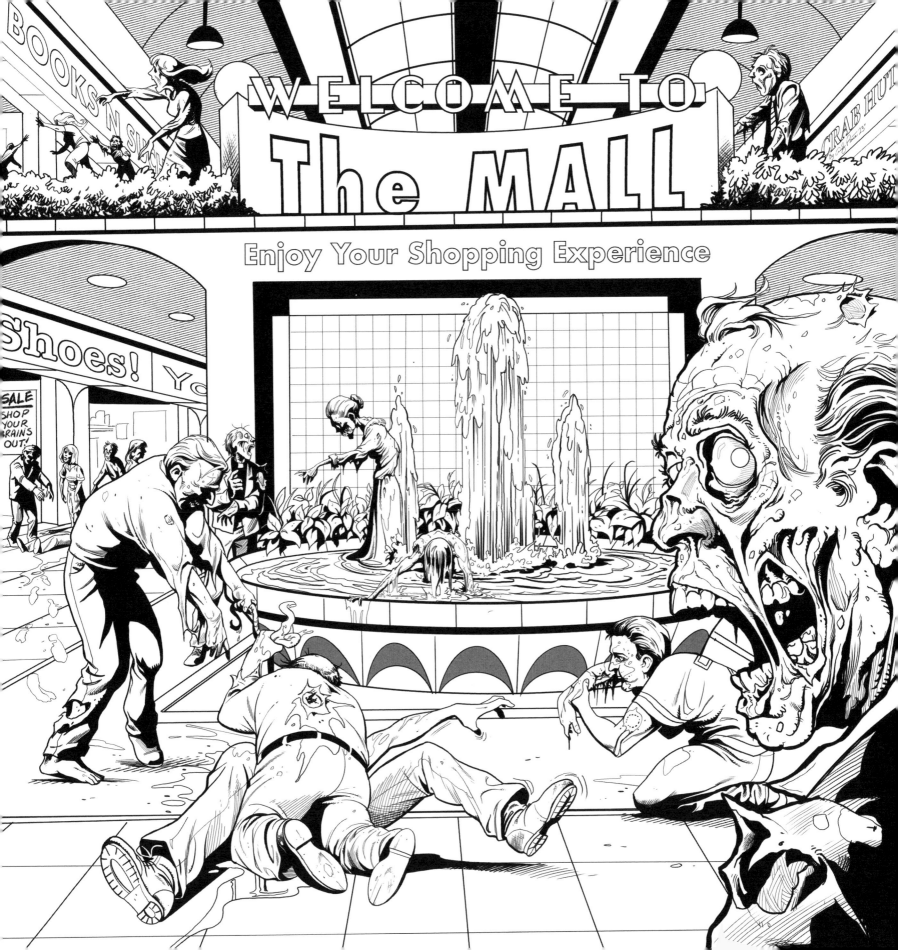

Dawn of the Dead, 1978

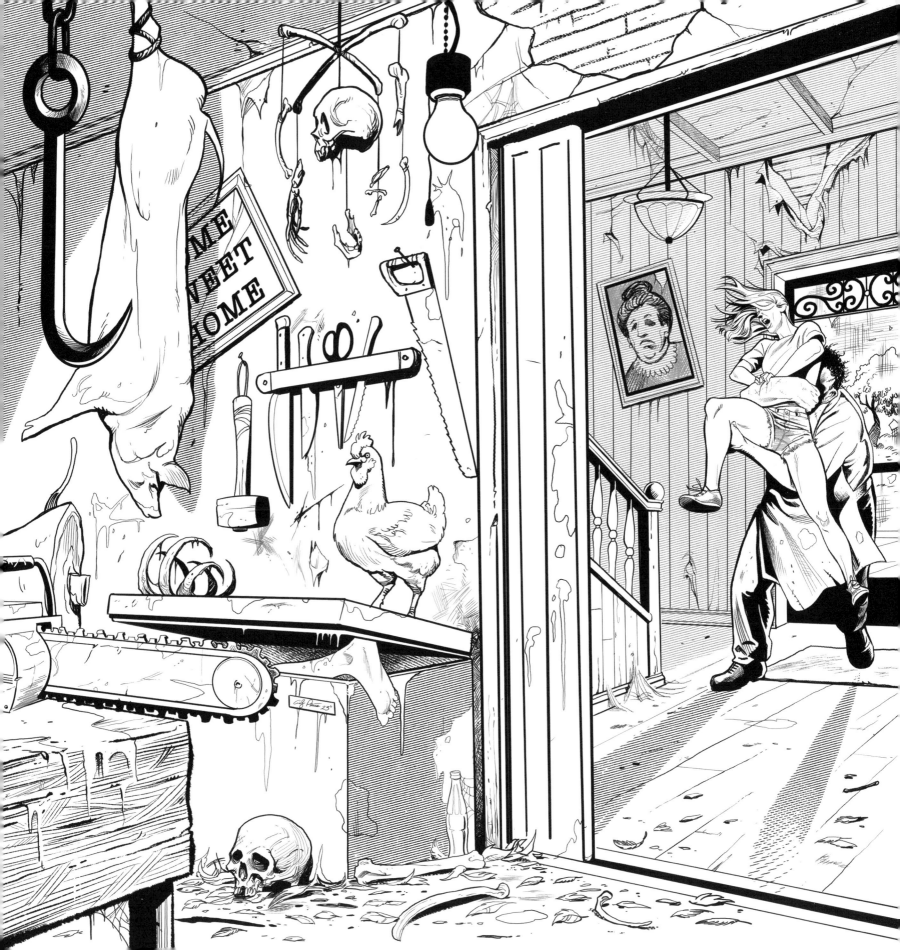

The Texas Chain Saw Massacre, 1974

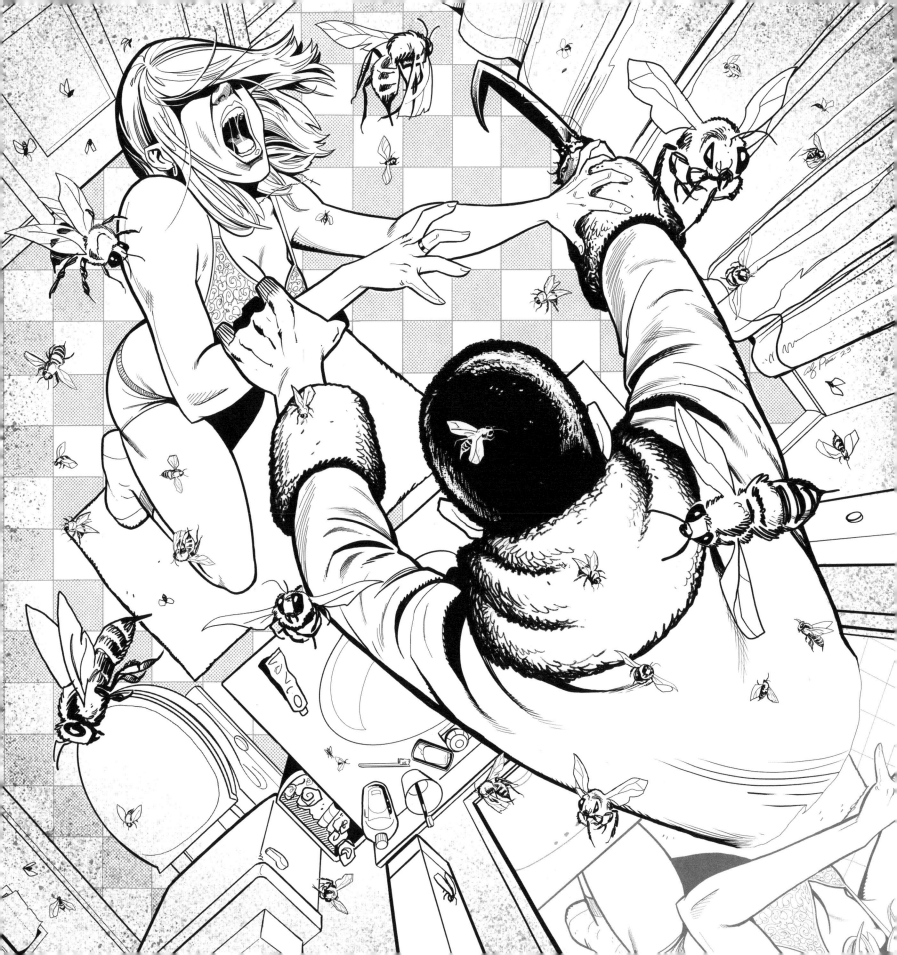

Candyman, 1992

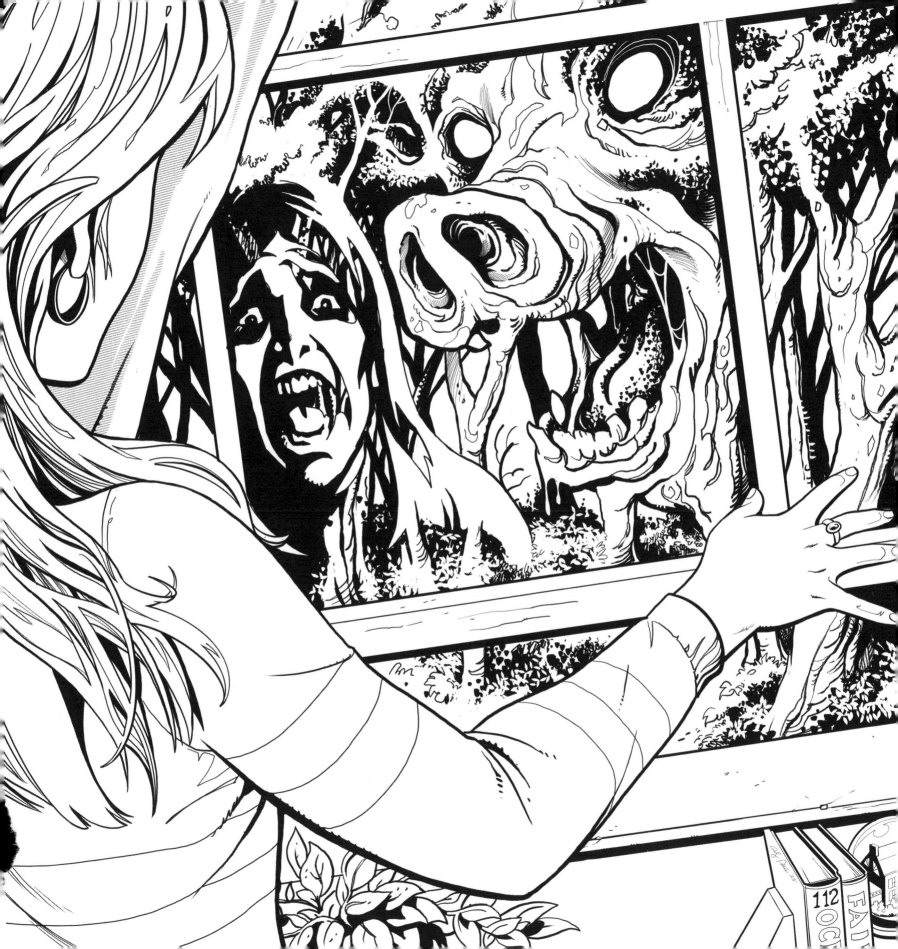

The Amityville Horror, 1979

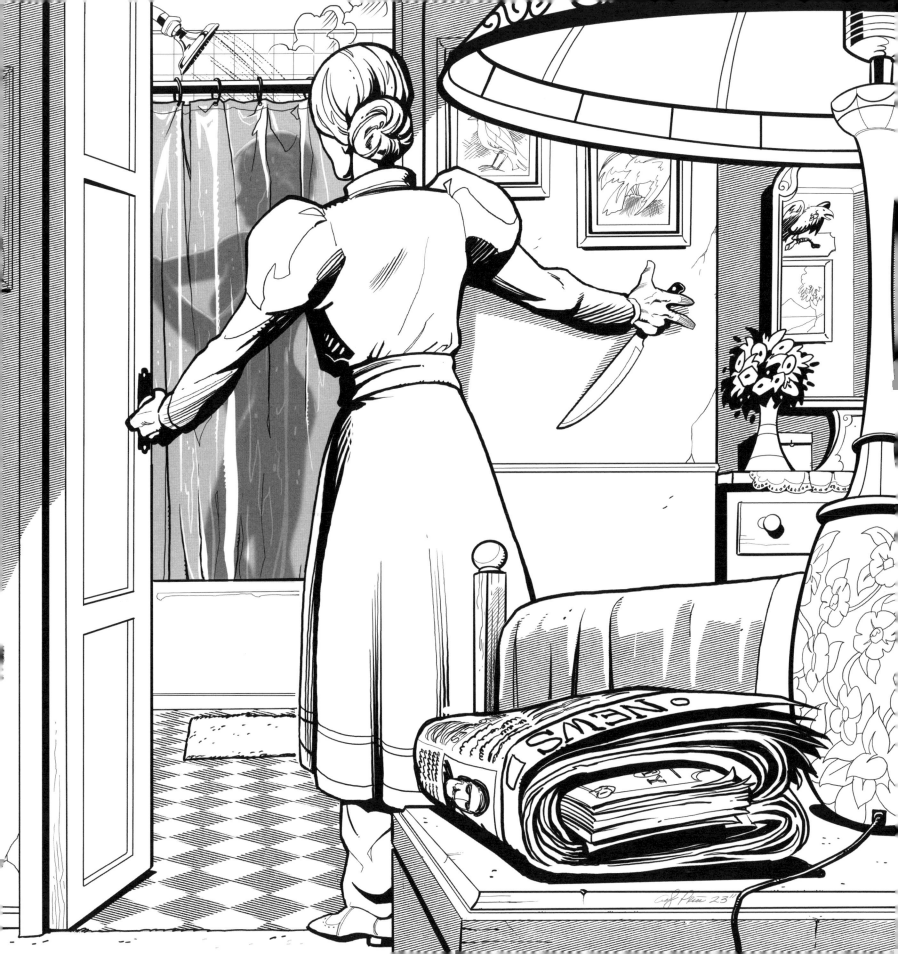

Psycho, 1960